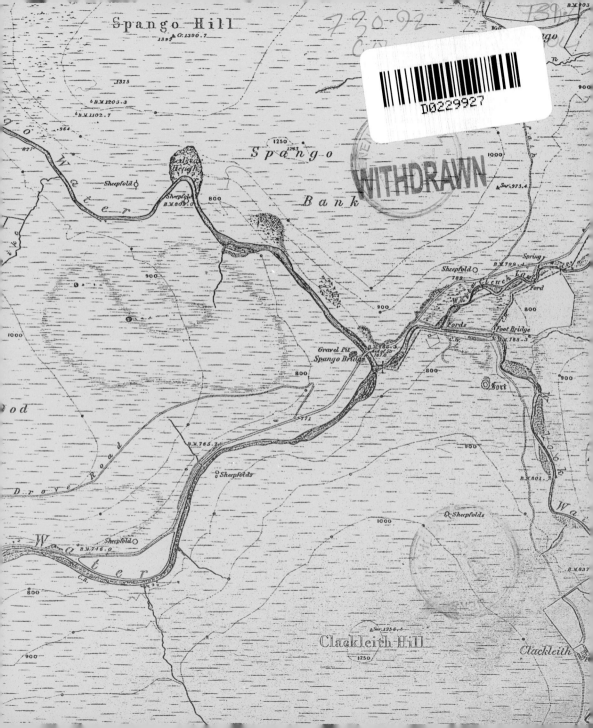

ARCH

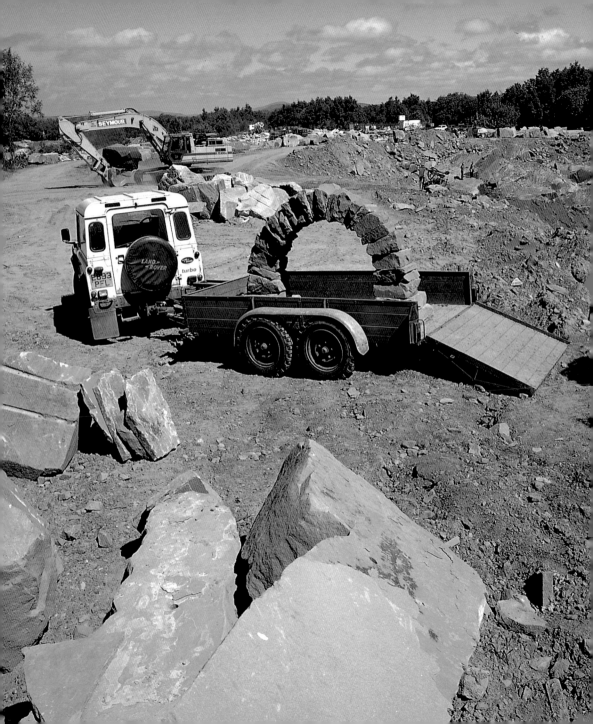

ARCH

Andy Goldsworthy
David Craig

THAMES AND HUDSON

First published in Great Britain in 1999 by Thames and Hudson Ltd, London

Produced by Jill Hollis and Ian Cameron
Cameron Books, PO Box 1, Moffat, Dumfriesshire DG10 9SU, Scotland

Filmset in Stone Sans and Stone Serif by Cameron Books, Moffat
Colour reproduction by Alfacolor, Verona
Chlorine-free paper made by Leikam, Austria
Printed in Italy by Artegrafica, Verona

British Cataloguing-in-Publication Data
A catalogue record for this book is available from the British Library

ISBN 0-500-01933-9

Drove Arch was commissioned by Cumbria County Council as part of a major public art project,
Sheepfolds by Andy Goldsworthy, and funded by Cumbria County Council, Northern Arts and The
National Lottery through The Arts Council of England.

Andy Goldsworthy wishes to thank Nigel Metcalfe and Katy Hood for their assistance
in building and dismantling the arch, and Steve Chettle of Cumbria Public Art
for his organisational skills and support for the project.

The artist is represented by: Haines Gallery, San Francisco; Michael Hue-Williams Fine Art, London;
Galerie Lelong, New York and Paris, Galerie S65, Aalst, Belgium

Endpapers: details of Ordnance Survey maps, published 1860 (*front*) and 1862 (*back*).
Frontispiece: Locharbriggs Quarry, Dumfriesshire, June 1997.

I will make an arch in Scotland from Locharbriggs red sandstone. It will be erected in a sheepfold on the Lowther Hills near to where I live, after which it will follow a drove route from Scotland through Cumbria and into Lancashire or Yorkshire. This is one group of work within the Sheepfolds project which will have its origin and destination outside Cumbria yet still leave its mark there, in common with the people, animals and things which have passed through this area over the centuries, leaving evidence of their journey but neither coming from nor staying there.

The arch will stay overnight at folds along or close by the drove route. It will be erected and photographed at each site before being dismantled and taken to the next. Some of the folds (still identifiable on maps) no longer exist; others are in need of repair. Several virtually derelict wooden folds will be rebuilt in stone, continuing what I see as a tradition of first drawing a fold with rail, fence or posts before it is made in stone. The arch will, wherever possible, leave behind it a trail of revived, working folds, a trail of goodwill.

Andy Goldsworthy June 1997

A number of farmers and landowners generously cooperated in the plan to find stances for the arch in or near sheepfolds.

Permission to make the arch on land belonging to The Buccleuch Estate, the Trustees of the William Farrer Settlement, and The Earl of Lonsdale and The Lowther Estates is gratefully acknowledged.

Thanks for their help in relation to the following sites are due in particular to:

Brian Dickie (Spango Farm)
Cyril Armstrong of Wm Armstrong (Longtown) Ltd
Mick North (Carlisle Civic Centre)
Frank and David Buckle (Milestone House)
Andy and Diana Holliday (Town End Farm)
Tom Felix and Ian Ratcliffe of Hanson Aggregates (Shap Beck Quarry)
John Greig (Thunderstone)
Keith Golding and Leslie Thackeray (Scout Green)
John Bennett and Miles Jackson (Grayrigg Common)
Arthur and Betty Pickthall (Lambrigg)
Frank Mason (Wyndhammere)
Mary and David Blanchard, John Nelson and Graham Stephenson (Fellside)
Diana Adamson (Tearnside)
Henry Bowring (Whelprigg)

The stones for the arch were supplied by Locharbriggs Red Sandstone, whose assistance was much appreciated.

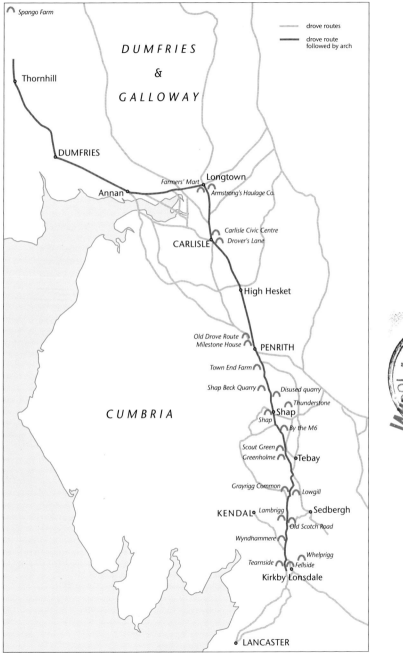

Spango Farm

DUMFRIES

&

GALLOWAY

Thornhill

DUMFRIES

Farmers' Mart Longtown
Annan Armstrong's Haulage Co.

Carlisle Civic Centre
Drover's Lane
CARLISLE

High Hesket

Old Drove Route
Milestone House PENRITH

Town End Farm

Shap Beck Quarry Disused quarry
 Thunderstone
CUMBRIA Shap
 Shap By the M6

Scout Green
Greenholme Tebay

Grayrigg Common
 Lowgill
KENDAL Lambrigg Sedbergh
 Old Scotch Road
Wyndhammere
 Whelprigg
Tearnside Fellside
 Kirkby Lonsdale

LANCASTER

drove routes

drove route
followed by arch

It has been good for me to return to the folds on the Lowther Hills. These folds, along with the circular fold at Winton, provoked a strong response when I first saw them, and I remain strongly motivated by them.

They are simple and circular, beautifully sited and made. I have already written (in *Stone*) about the influence and lessons that the dry-stone wall has had for my work – the way a wall is made and the line a wall takes. The Lowther sheepfolds have taught me about enclosed space and about the place in which the fold is made. They are incredibly sculptural, and the compressed space that they contain has such a strong atmosphere.

The more I looked for a fold in which to begin the drove arch, the more selective I became. There were practical criteria determining the site which stopped me from using many that I would have loved to have worked in. It needed to be near a road so that I could bring the arch to the fold and take it away afterwards. As I began to look at the folds, I realised that I wanted one that expressed the strongest quality of these Lowther folds: their simplicity. I also wanted to find a balance and a relationship between a circular fold and the semi-circular arch. I found several that had a wall attached to the circle as a collecting device. Although I liked these, I was looking for something more simple.

As the arch project has progressed, it has become more important that the folds I work with need repairing or rebuilding. I have found many simple circular folds next to tracks, but these were in good repair.

Whilst looking for the fold, I met several extremely interesting farmers, some of whom have great knowledge of the folds, or stells, as they are called here. A farmer's wife actually accompanied me to some folds up on the hill.

I was told by one farmer that the first stells were made by a man from Hawick, over in the Borders, who used to be a seafarer and had studied the ways of water and wind. He came up with the correct proportion of height to width to make a sheepfold that didn't collect snow. He couldn't tell me the name of the man, but I would love to find out more and see some of these folds. He told me that some of the folds worked and some of them didn't. One, in particular, was too large. That these stells originated in the mind of a man looking at water and wind is for me a vindication of some of my own approaches to working with folds.

After some searching I found a small, semi-derelict, circular fold in a grass field full of sheep. The farm is nearby. I liked the relation-ships between fold, field, sheep, farm, fells. The farmer, Brian Dickie, was enthusiastic at the possibility of the fold being repaired as he could find a use for it. He offered to bring stone to help.

Saturday 7th June

Today I went to Spango Farm and made the first arch in a fold that will begin the drove route. The arch looks well. It is a good size and has a good spring to it. This fold is derelict in places, so I had the arch stepping over the wall, out of the fold. The grass is green and vivid. The contrast between the red sandstone and the grass is strong.

The day was very windy with occasional showers which darkened the stone on one side where the rain had been driven against the arch. Brian Dickie kindly took the cattle out and left the sheep. The sheep will not harm the arch, but the cattle would have rubbed up against it and possibly knocked it down.

I had hoped to go back this evening if the sun had come out, but it hasn't. I will get up tomorrow morning in the hope of photo-graphing the arch again, possibly in sunlight.

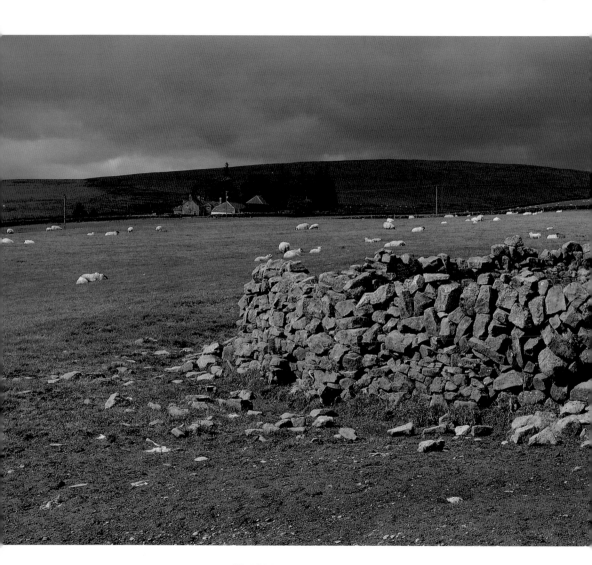

SPANGO FARM, DUMFRIESSHIRE
7-8 JUNE 1997

10

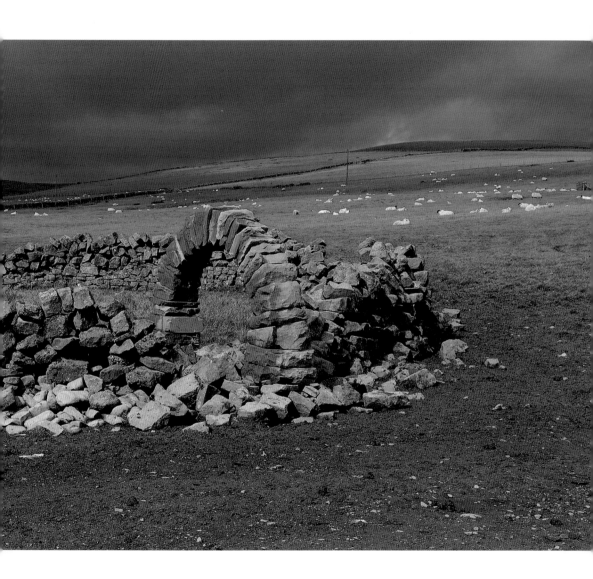

A good start. I feel slightly nervous about the journey that I am about to take. There is a sense of responsibility about taking the arch from Scotland through Cumbria. I only hope that the farmers that I meet along the way are as interesting and open-minded as those I have found in the Lowthers. They may not have entirely understood what I am doing, but they are tolerant enough to allow it to happen, and with some enthusiasm.

Sunday 8th June

It rained overnight. The arch was wet and dark on one side. There were many sheep around the fold. Although it seemed mainly cloudy, the speed of the wind meant that there was constant change and more chance of the sun illuminating the work. The biggest problem in taking the photographs was the wind (which shook and vibrated the camera), coupled with the difficulty of trying to take an exposure from a patch of sunlight lasting only a few seconds. It began to rain, and was dark and overcast for some time, so I decided to take the arch down.

We took the arch apart, placed it on the trailer and drove down the motorway to Longtown, the first site in Cumbria.

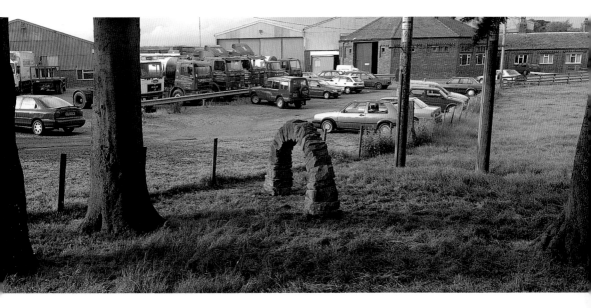

ARMSTRONG'S HAULAGE COMPANY YARD, LONGTOWN, CUMBRIA
8 JUNE 1997

Longtown has a market, and a fold used to be sited nearby. The original market is now the yard for Armstrong's Haulage Company. It seems somehow appropriate to have the arch resting in a place that deals with the transport of animals. It is impossible to make the fold on the original site, so I have relocated it.

I made the arch twice. Not happy with the first alignment, when I realised that the arch was related too strongly to the shape marked out for the fold that will be rebuilt. It did not have the quality of a confined animal – not that the arch is in any way an animal,

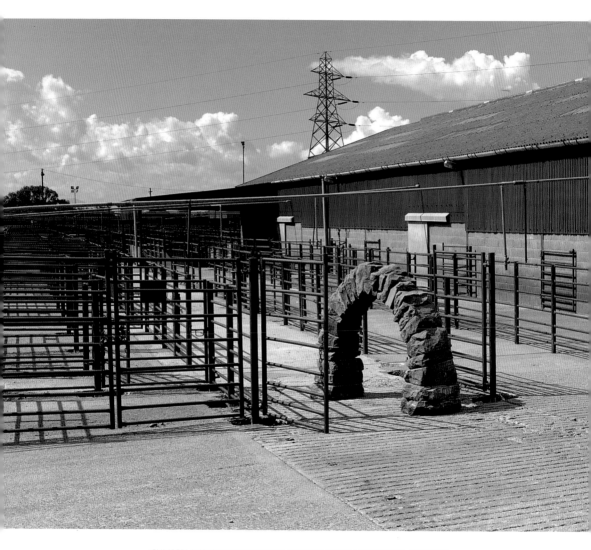

CUMBERLAND & DUMFRIESSHIRE FARMERS MART, LONGTOWN, CUMBRIA
9 JUNE 1997

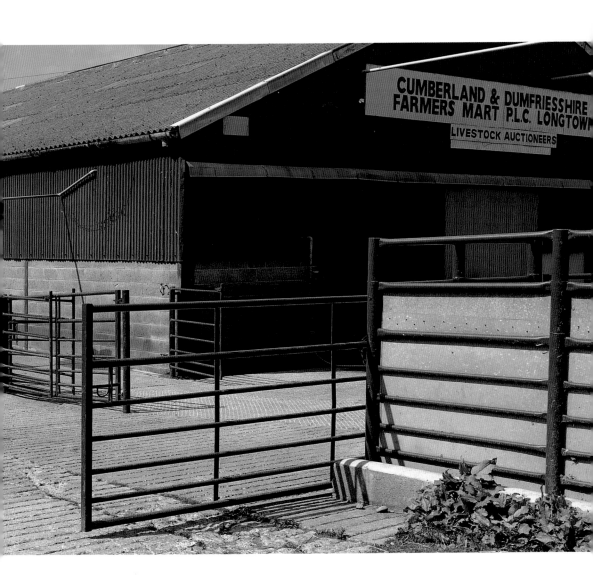

but there are interesting rhythms and movements that can be interpreted sculpturally in response to the energy, reactions and movements of an animal. A sheep would not be aware of the fold to come, and my arch should not be either. It should be separate from it, yet at the same time contained within the space that the fold will eventually enclose.

The arch is resting amongst a group of magnificent sentinel beech trees which in themselves have the feeling of enclosing the arch – a fold of trees.

It is so different making a sculpture for the moment to making one that can be seen at all times. Photography becomes a way of understanding and extracting an idea from the piece. There is an intensity about this process that I don't feel when I make a work that will be there for a long time. I like and dislike it for this reason. I dislike it because it is hard and a strain and a burden. I am con-structing the story of this arch in images. I have to extract from the journey the visual story of the arch. Making the arch itself in the various places is becoming less of a challenge than drawing the work together.

Tomorrow we go to Carlisle, possibly the most difficult site of the journey.

Monday 9th June

Uplifted the arch from Longtown. Went to tell the people at Armstrong's that I was leaving, when I noticed the interior of the old auction mart. Thought that would be a great place to make the arch, then realised that across the road is the new auction market. I went to have a look. There is a quite extraordinary mass of pens made of red-painted metal. Went to the offices and asked the manager if I could make the arch in the market, and he agreed.

Even though there are no animals here today, there is a strong sense of their presence in the system and structure of the pens, a feeling of movement in the way that one pen becomes a corridor to another, and to yet another, to the ring, to the wagons. They are like a microcosm of a field system. In some ways, the absence of the sheep leaves a stronger sense of their presence. I think this may be what I want to achieve with the arch, for the memory of it to be as potent as its presence. I know that the more times the arch is made, the richer it becomes. It gathers up something of each place and takes it on to the next. There will always be a connection to the places where it has stopped.

I am pleased that we are managing to make the arch reasonably quickly. This gives me time for detours and stops within the day in between the nightly stop-overs at folds.

Carlisle Civic Centre

A windy, noisy, hard place. One of the reasons I wanted to use it was to show how dramatic the changes have been here. Hard to identify the exact position of the original fold from old maps, especially as the course of a river has been altered. A building probably now stands on the ancient site of the fold. I have decided to place the arch as near to this building as possible.

Making the work in the town centre has required much involve-ment with the authorities. The access department is of the opinion that a circular fold would help in terms of movement of people. I am happy for what was once a square fold to become a circular one, but that will come later.

Pedestrian barriers had to be placed around the area where we were working. This in itself became interesting as a kind of urban fence/fold preceding the fold that we will eventually make. It is

interesting to see the arch go from a hill to a roadside to an auction mart to a city centre. It is really gathering up the places. We are getting quicker at making the arch. Obviously it is easier when the ground is level and hard.

Just up from where we were working, there is a lane called Drover's Lane. The name of the road is attached to a sandstone building – the same kind of stone as the arch. I cannot resist it and tomorrow we will make the arch next to the building and the sign. I will do it early in the morning while things are quiet.

It is so reminiscent of one of the very first works I made outside in Bradford during my Foundation Year there when I took a series of free-standing wooden frames around the city centre at 6 am on a Sunday morning, placing them in situations where they became like people. I took them to police stations, placed them in telephone boxes, and so on.

The photography continues to be hard going. I don't know why, but it seems to be more complex than ever before, possibly because the arch is a permanent work, which nevertheless demands the same attention that my more ephemeral work would require. It is unusual for me to work out a site through the lens of a camera before I make a piece, but today I did this. I think it is because I am having to work to so many coordinates. There is obviously the arch itself, but there is also its relationship to the site. The Civic Centre is a large square building, with a road running alongside it, and I like the connection to the road. The biggest consideration of all is the fold that will be built later. I have to bear all these things in mind when taking the photographs. If I just wanted to photograph the arch it would be far easier. But I want the focus to be not so much on the arch itself as on the site.

As the work is in a very public position, it is important to show the movement of people. But when I came to take the photographs, there seemed to be very few people around. I also wanted to take the picture at a moment when the sun is out. There comes a point when I almost say, that's it. I just have to stop. If I haven't got it now, then I have to accept that I will not have what I want.

It was a good atmosphere. In the end, what might have been a difficult place turned out to be relatively easy.

I have left my assistant Nigel, with the help of students from Cumbria College of Art and Design, to act as guardians to the arch overnight. I will get up early to see them. After making the arch at Drover's Lane, we will take the arch to Penrith where we have a potentially difficult site to get to. It is down a steepish hill, and I realise how the Landrover and trailer struggle on wet ground with so much weight.

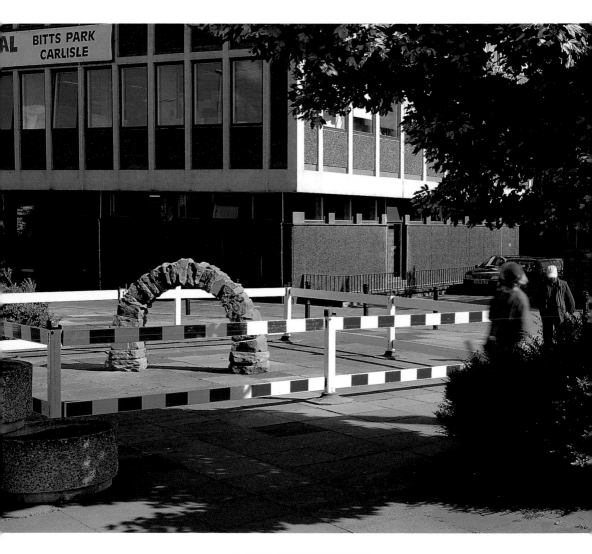

CARLISLE CIVIC CENTRE, CUMBRIA
9 JUNE 1997

20

Tuesday 10th June

Got up at 6 am to uplift the arch from Carlisle Civic Centre, then took it to Drover's Lane. It was a beautiful sunny morning, and I photographed the work in the shadow of a large tree. I like the quietness of the light. It made the form of the arch interesting against the form of the building – two forms out of the same material, the difference being that one was more recently hewn from the quarry. It is so easy to make. I love the way that an arch which is expressing stability, work and time, is made so effortlessly and quickly. It has meant that the arch can go off on detours and pause in resting places that I had not anticipated. These even more temporary installations of the work could perhaps be important links between the folds on the journey.

Old Drove Route, near Penrith, Cumbria

On the way to the next site, there is what may well have been an old drove route. As a new road has been built, it now leads only to one or two farms, but it still retains the character of a main road. I know that it is possibly a drove route, because of the large grass verges and walls that flank it.

We made the arch on the road itself. Out of all the arches, this is the one that has the strongest feeling of movement. The road and the walls seem to give the arch a real sense of direction and energy.

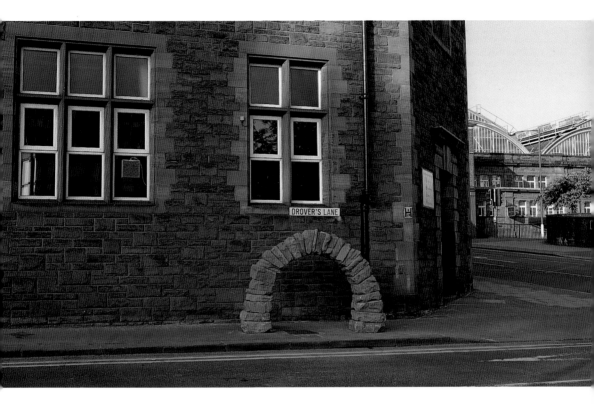

DROVER'S LANE, CARLISLE, CUMBRIA
10 JUNE 1997

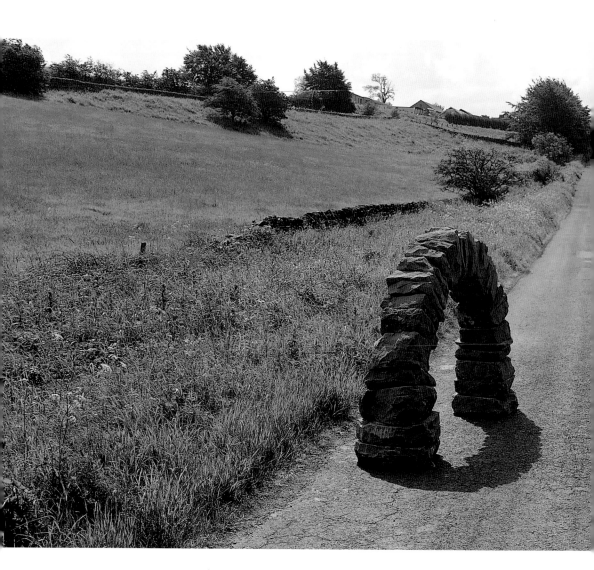

OLD DROVE ROUTE, NEAR PENRITH, CUMBRIA
10 JUNE 1997

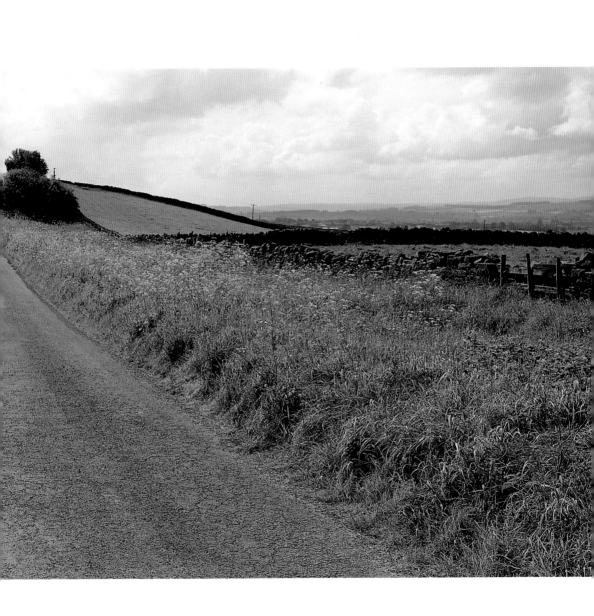

MILESTONES, THUNDERSTONES
David Craig

The arch that Andy Goldsworthy drove from Locharbriggs Quarry, north of Dumfries, to Whelprigg in Lunesdale in the summer of 1997 arose twenty-two times on its journey from source to resting place, like an ochre sea serpent with twenty-two humps. At the end of each day it was like the upper segment of the sun still glowing just above the horizon. In the morning, it was the sun's brow rising above the skyline in the east – fittingly, as this was a maquette for a 100-ton arch (made of pieces split from the same rockface) which was to be built at the Cirque du Soleil in Montreal.

Here in north-west England, the arch seemed homely, unassuming, cattle-sized, jogging down drovers' routes that nose between the fells, across watersheds, and down dales that open out at last into the lowlands. I met it at Milestone House on the A6 north of Penrith. Almost everything travelling up or down the west of England has to pass through here – the old main road, the Glasgow/London railway line, the M6 motorway, and, this morning, two RAF Tornadoes tearing up the vale between the Lake District and the Pennines. The cattle used to walk this way – and the sheep – from Galloway and Liddesdale and points west and north, grazing on pasture at High Hesket before heading towards the markets and slaughterhouses of the south. Here the arch has just arrived in its lowliest form – twenty-nine red stones, with a tin ladder and wooden posts, in a trailer towed by a Land Rover.

The old sheepfold site at Milestone has been occupied by a newish one, with breeze-block walls and concrete floor. In the dipping trough, nettle seeds swim lazily on foul brown liquid, above a ghostly remnant of polythene. Andy and Nigel Metcalfe, his assistant, trample down the nettles and bridge the trough channel with old fence-posts. They pass red stones from hand to hand, place them for the arch's feet, then rock on them to test for steadiness. When four are set solidly at each end of the arch, the hollow centre is built up with cement

bricks and old wooden blocks. Perched on top is the form – the wooden bow on which the stone one will begin its arc through space. 'It's nice to build an arch over an arch, instead of scaffolding.'

Stone is poised on stone, each wedge-shaped block tapering inwards. Andy has chosen and cut them from much larger pieces at Locharbriggs whose banding or bedding-planes – faint, dark lines in the red – converge instead of lying parallel. These layers may be traces of coal or oil or volcanic dust, according to Eric Sawden, manager at Locharbriggs, and he is proud of them. 'You can tell our stone by them. There's nothing like them at St Bee's Head' – the slightly younger Triassic sandstone forty miles due south across the Solway.

Now the arch is curving gracefully towards completeness, its arc echoing the humped capping-stones of the sandstone field dyke a few feet away. The last, thin piece, the keystone, has to be struggled into the two-inch slot remaining at the crown of the arch. As the day grows sultry and a thundersome blue trunk of cloud leans its electricity towards us from the south, Nigel blames the nettle flowers for his hayfever.

'Surely you shouldn't get it from *nettles*.'

'Nature will get him yet,' says Andy.

'I'd come back as myxomatosis,' says Nigel with cheerful malice.

The arch is finished, the wooden form and its pedestals pulled out from under, leaving this serene and rugged presence, pink as salmon flesh, pointing westward towards the trench of Ullswater and the way through to Keswick between Clough Head and the high-piled shapeliness of Saddleback. As the arch is dismantled for the drift south, I notice that a barn two fields away is slowly losing the flag slates off its roof and the recently bared unweathered ones have kept their colour, the arch's colour, a warm peach which looks sunned even on days of overcast.

The arch is 200 million years old, the geologists would say. It is made of Permian New Red Sandstone that formed gradually from dunes surrounding isolated salt lagoons when Britain was in the latitude of northern Africa. Actually it must be far older than that. Locharbriggs sandstone is 98.5% quartz (dyed red by salts of iron), which crystallised out of the original, molten material of the Earth. Then it was pulverised into sand by the shattering electric storms and

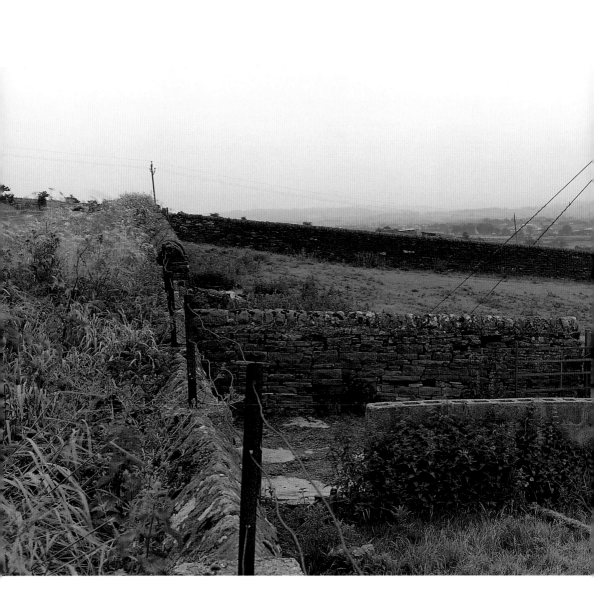

MILESTONE HOUSE, CUMBRIA
10 JUNE 1997

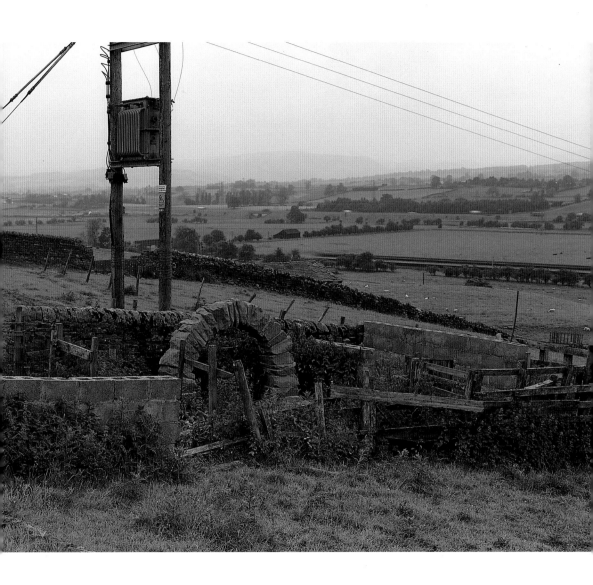

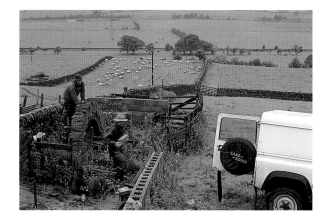

Milestone House, Cumbria

The farmer has said that he doesn't use this fold for dipping any more and would prefer it to be replaced by a stone fold, a simple, single-chambered pen which he would use for working with the sheep and for shelter. The field walls are made of sandstone; building the other two sides would make the fold fit well into this place. It was sunny to start with, but as the day progressed, ominous, dark clouds came over, and there was a heaviness to the atmosphere.

Wednesday 11th June

Heavy rain overnight. Difficult to uplift the arch because of the steep hill getting out of the field. Long, hard work. Didn't leave until late morning even though I took no more photographs.

floods that raged for much of the planet's youth. Great dunes of it were fused and compacted into rock as the Earth settled down. Now the stone must take its chance among the diesel exhaust and tarmac, schoolchildren and cattle-floats, as it follows drovers' ways out of south-west Scotland, across the Border by the flat-lands of the Solway, a hundred miles through Cumbria on the long drift south.

In older usage, the word 'drift' had two special meanings: 'the driving of cattle within a forest to one place on a particular day' and 'the horizontal thrust of an arch'. Nothing to do with floating dreamily and everything to do with onward, or sideways, force. Elsewhere, there is even a green lane called The Drift, which forms the Leicestershire/Lincolnshire border for many miles between Stamford and Newark. This was a track as long ago as the Bronze Age. More recently, drovers used it instead of the Great North Road because it had no tolls. Drove roads are like that – grassy alternatives, now often recognisable only by their treble width that gave the animals browsing room between the drystone walls. 'Drove road' – for me it will always be a stony, hollow way with turfy banks that slants northwest out of the Howe of Cromar in Aberdeenshire. I walked it summer after summer, knowing only (because my father told me) that herds had passed that way towards distant marts. They were coming from the cold up-land of the Cabrach beyond our favourite mountain, Morven, making for lusher pastures down by the Dee before heading through the Mounth for Falkirk Tryst, perhaps England in the end. I see it now in sunshine, its banks like ramparts keeping back the sea of summer bracken where our holiday spaniel, Snooks, ran down rabbits and the shaking green plumes told us where he was.

There is hardly a favourite way of mine in Scotland, and now in England, that wasn't once a drove road. The Lairig Ghru carried us twenty-two miles through the Cairngorms by a great V-cleft from Deeside north to Speyside. South again, a drove road cut through from Glen Callater to Glen Doll in Angus, swamped at the watershed by peat haggs so deep that we lost all sense of dir-ection between slithering into them and clawing out again. On its eastern neighbour, the Capel Mounth, herds of red deer more than two hundred strong streamed like wild cattle across the high pastures. From the 15th century, and as late as 1900, drovers walked the Pass of Corrieyairack from the Great Glen through to Speyside, sometimes with a piper at their head.

My favourite harbours were once drovers' gathering points: Lochmaddy and Locheport, the wide and the narrow eastern mouths of North Uist, where beasts were loaded for shipping over the sea to Skye, as were evicted crofters bound for Australia and Canada; the little ferry from Glenelg to Kylerhea on Skye, always the finest way on to the island, where cattle were roped nose to tail for the swim through the unruly meeting of currents; Kinuachdrachd at the north end of Jura, where the island's only road has grown so swampy that you must drive at walking pace and the deer stand drinking at the fords, scarcely moving as you trundle past.

All these are places that my mind's eye sees in sunlight – the weather of nostalgia and fond recall. That emotional freedom is rooted in economic freedom. Originally, drovers were able to pasture their herds for nothing, often evading toll points and living on their staple of oatmeal, onions and a ram's horn of whisky, supplemented by wild game. Their way of life declined as the pastures were walled in, and the wayside grazing was destroyed by the cuttings and embankments for improved roads. Farmers began to charge for the nightly stances, and the lairds closed the corries – the great basins of summer grass on the faces of the mountains – because they wanted the red deer to be fine and healthy when they shot them. By 1850 most of the green arteries were disused. The traffic moved first to sailing boats and then to steamers. In their holds a horrific number of animals smothered and died.

The drove-roads that remain are visible history. History of another kind came into sight at the arch's next stopping place, Clifton, south of Penrith. Town End farm is on the site of the last battle fought on English ground. Andy has spotted a barn whose doorway is headed by an arch of thirteen handsome sandstones. His arch will echo it, making a slightly tighter curve. Prince Charlie's retreating army was caught and routed here in December 1745. I bleed for the men (quite possibly recruited on threat of eviction by their feudal overlords) who were tortured and hanged here, perhaps on the huge oak called the Hanging Tree a few yards down the lane.

As the arch starts to rise and glow in the shadowed mouth of the barn, conversation begins to bubble amongst the dozen people who have gathered. Stephen Bland, who is about to move into the house across the road as his

parents-in-law move out, believes that the battle victims were killed a little to the west beside the River Lowther. He too has noticed how all routes flow through this neck of England and says with satisfaction, 'If you liked, you could bring the country to a standstill, if this was all blocked up.' The farmer's wife has actually written a thesis at college on Andy's work. Passers-by, cameras in hand, are discussing which of his books they like best. Everyone is watching as though a sword-swallower has arrived to display his art, or a juggler is throwing stones from hand to hand in a bewilderment of interlacing curves. When the form is taken away and the arch stands there without a quiver, an 'Aah' runs round the little group.

Town End Farm, Clifton

A meeting of two arches, one bound by a building and one re-leased from the quarry. It made me wonder whether the arch's final destination might be in a building. I still quite like the idea of it ending up protected by a shepherd's hut.

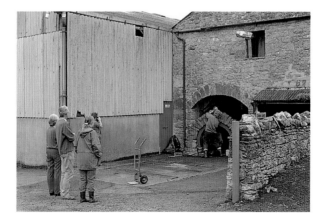

TOWN END FARM, CLIFTON, CUMBRIA
11 JUNE 1997

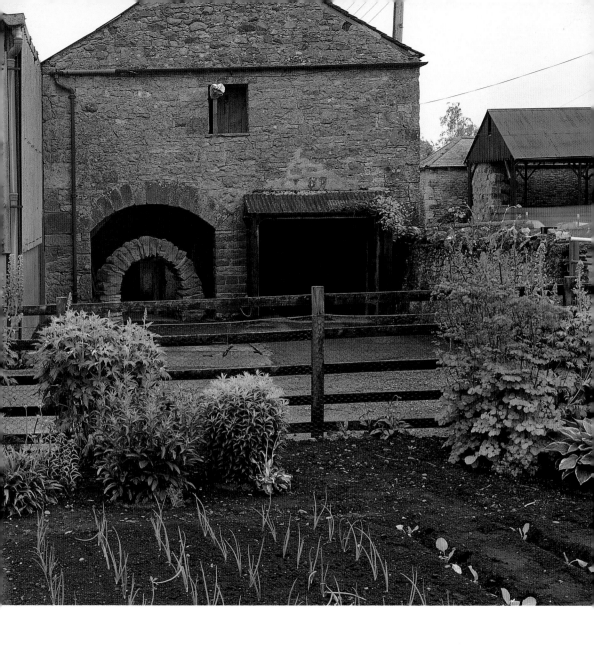

At the centre of it all is something down to earth, a bow of stone between five and six feet high, with the elastic strength of a packhorse bridge. One foot is on the threshold, the other just outside – today the arch is a brown horse sidling out from its stable into the light, a thick, bluish light by now, a degree of gloom. By the time we reach Shap Beck Quarry, set on a sickle of carboniferous limestone that curves north and west from Ravenstonedale to Cockermouth, fat raindrops are sliding off the willow foliage into the nettle beds beside the land-scaped approach to the massive workings up the hill. Making a virtue of wetness, the arch will stand with one foot in the beck, just upstream from a pool with stone-built sides which Nigel believes to have been a silt trap.

We are still on the old arterial route. The A6, running south to Shap, is a few yards to the east, and next to it the West Coast Line is carried over the beck on a steel bridge. All afternoon the roar of metal wheels comes barrelling out of the culvert a little downstream. The quarry machinery rattles and hisses as stone is milled to aggregate. Traffic growls, peaks, and diminishes on the tarmac. To one side of all this, steeped in the odour of cats and aniseed secreted by crushed nettles and cow-parsley, the arch grows, not without difficulty. An under-water foundation stone, an old, masoned limestone block now smoothed by the flow and oiled by algae, is proving hard to stabilise. After five sandstones have been built up on it, the thing is rocking. Nigel reports that it is over-hanging its own footing in the water, and the weight of the rising arch is forcing it outward. They begin again. Each stone has to be hefted down from the man deep in nettles to the man deep in water and changes hands laboriously in a slow-motion rite. When things look good at last, Nigel does a few steps of a peasant dance on the low pillar, water flying from his boots, and crows 'Hey!' in triumph. He clambers onto the bank again and holds up his arms to let water stream out of his orange industrial gloves.

This time, with its limb in the beck much longer than its limb on land, the arch is a segmented animal drinking deeply through that long, dripping trunk. Quarrymen have arrived, in suits, hard hats and dayglo yellow over-jackets, intrigued by the project and satisfied that their favourite material, limestone, has found yet another use. They regale us with the facts of their craft and trade and reel off surprising uses for the stuff, culminating in the

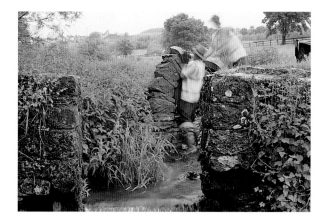

Shap Beck Quarry

The site is by a stream, where a (now-vanished) washfold once stood. Sheep would have been washed in the river before shearing. I had always hoped to put the arch in the water here, but after the heavy rain, I felt somewhat uncertain. The stream is not that high, but if it continues to rain, there is the possibility that I might lose the arch or at least have great difficulties getting it out of a stream in spate. At first I thought I would put both of the arch's feet in the water, but then decided to place one foot on the bank and one in the stream, in the spirit of an animal leaping out of the fold, from the bank into the water. It was a tough piece to make, very physical. We were tired after the day's work, and it took two or three times to get the arch stable.

After we finished, I was pleased with the piece. This has been a good day in which the arch has both taken and given much energy.

Overleaf
SHAP BECK QUARRY, CUMBRIA
11 JUNE 1997

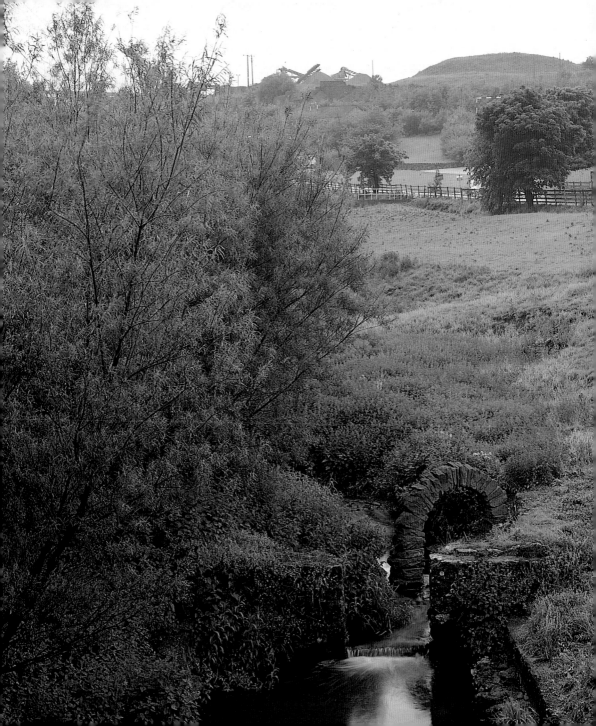

mixing of it with hot rubber to make carpet underlay.

'You don't believe us, do you?'

'What about nylon stockings?' I suggest, remembering how our geography teachers impressed us with the versatility of coal. 'And I saw a truckload of rockery stone coming out a minute ago.'

'That's only a small part of it. Over the country, we all use twenty tons of it each per year.'

One of the men is so taken with the arch that he turns up several times at our stopping places further south. Wherever I have gone, the quarrymen I have met or whose memorials I have seen have been imbued with this respect or love for the stone. It happened at Locharbriggs, now at Shap Beck, and a few years ago at Elterwater in Great Langdale, where my wife and I went to buy some greenslate for stair and windowsill tiles. We were treated with the utmost hospitality by a foreman who showed us how to choose a piece that would split evenly, demonstrated with hammer and cold-chisel, and spoke admiringly about Jim Birkett, greatest of Lakeland rock-climbers, whose famous hand strength grew from his work as a river, splitting slate in these quarries.

As for the quarrymen's memorials, if you go to Rivelin or Tegness, west of Sheffield, to Mow Cop above Leek in Staffordshire, to Penrhyn in North Wales, to the quarry known as El Medol near Tarragona in Spain or the one called Le Pyramide just south of St Rémy de Provence in France, you can see the monuments – pillars of integral rock left standing when they could so easily have been reft or blasted down and carted away as stone. There they tower, many yards away from the worked rock that once surrounded them: the Old Man of Mow, a hunchbacked Cubist sculpture, in the middle of what was a source of millstones from medieval times; Tegness Pinnacle and Rivelin Needle, tusks of gritstone, which draw climbers like magnets; El Medol, a golden finger of the stone from which the Romans built Tarragona and the aqueduct which still spans the river nearby; Le Pyramide, a white and yellow bone of a rock, now standing amidst lavender fields, a few yards from some of Van Gogh's most famous landscape subjects, just down from the wells, baths, and temples to Hercules for which the Celts, the Greeks and the Romans quarried the blond stone.

Why did they leave the pillars standing? Surely as totems, to honour the

stuff of their livelihoods, with an eye too on the cult of virility still audible in that name 'Old Man', given to so many rock stacks, whether natural or quarried. So Andy's arch is a portable totem, built to celebrate this fire-coloured material from which much of Glasgow was built, to say nothing of the foundations of New York's Statue of Liberty, placed at the harbour mouth where Dumfriesshire sandstone arrivèd as ballast.

The next landmark we are steering for is 'the thunderstone near Shap'. The arch has a mind of its own – it is Andy's mind, actually – and when I find my way next day to one of the neighbourhood's many thunderstones, the team (augmented now by Katy Hood) is nowhere to be seen. I cast about in the lush pastures of the old Shap Abbey hayfields, nourished by limestone. Here a grey boulder shares its space with a herd of young beef cattle. Apparently not the one – the farmers have heard nothing about a drifting arch. Not far away, where four dykes meet in a cross, the Gogglesby Stone stands amongst green hay, its wrinkled backside turned towards me like the rear-end of a ruminating elephant. It is bollard-shaped – surely not left standing on its narrow foot by nature – set up, then, as an altar to Thor, who was worshipped as the thunder-god by the pastoral people who lived here many hundreds of years before the Christian missionaries arrived. The word 'thunderstone' suggests a colossal hailstone, and indeed these boulders arrived here in their hundreds as erratics, rafted across the country by the lobe of Irish Sea ice that reached inland north of the Lakeland mountains and drove over Stainmore into Teesdale. Most of them, like the Gogglesby Stone, originated in this drainage area, plucked from the granite batholith which mounded up in the Earth's crust and is gradually, over the millenia, becoming exposed by weathering, as the sandstone and limestone laid on top of it are worn away.

It is still the wrong thunderstone – no arch is rising into view in all this wet green quietness. I retreat past Keld, where the Buttermarket Cafe and Craft Shop stops me in my tracks. Three arches make up the facade, now filled by two windows and a door. Arches are 'home' now, and I pause for a sandwich and to view these fine limestone arcs, broader and flatter than ours, resting on squat pillars. When I get back to the A6, I find the red arch taking shape in a lay-by at the foot of a ten-metre-high quarried limestone face. Andy had liked

the look of it, as a natural drovers' stance, so they began to build. A big cattle-float and trailer pulled in, so they began again, setting the arch against the backdrop of this motorised herd.

'Sheep?' I ask the massive lorry-driver.

'Cows. And I put a bull in the front just now. A bad bull.' He looks down at a bleeding weal on his hand.

The metal-sided pens-on-wheels are steaming above and dribbling piss below. Chris Forster is a cattle dealer from Haigh Home Farm near Wigan, so he is a drover right enough. Livelihoods have changed, it is the age of mad cow disease, and these animals are being taken down to the slaughterhouse at Oldham, after which, I suppose, they will be rendered down and used for fuel in a power-station. As a beef man, Chris is reluctant to blame cattle-feed and believes that they are covering up the real cause of BSE – organo-phosphates. He goes on about this for some time. Then, like any drover, he gives orders to a bedraggled and muddied collie, Glyn. Glyn lies down, belly hugging the dirt, tail straight out behind him, and points his muzzle at the arch, as though suspecting that it may suddenly start up and gallop off.

It looks as though the thunderstone is going to remain on the horizon for some time yet. In Shap town, Andy's eye is caught by yet more handsome curves – two trios of arches, on the east and south walls of a characterful gem of a building on the main street. Surely it was built by the same mason as the Butter-market in Keld? It is the Market Cross, put up when Shap was granted its charter in 1697, now glazed and housing the Library. 'When I see an arch like those,' says Andy, 'it's like meeting a friend. Another animal of the same species.'

He will build the arch on the pavement beside the northernmost of the Cross's six. Its warm curve rises, as though emerging newly baked from the old grey oven just behind it. This building, it turns out, is all arches – many eyes with many brows. Two small ones top the first-floor windows and yet another has been almost effaced by infilling on the north side – 'captured by a building', as Andy says, whereas his arch 'is still free'.

The town is alive with stones today. In the playground of the school across the road, limestone fish and eels and lizards are twining between the low street wall and the buildings, skirting a tree, rounding the feet of a notice board.

DISUSED QUARRY NEAR SHAP
12 JUNE 1997

Two wallers are building to the design of an environmental sculptor from Carlisle called Linda Watson. Her works might have been just seats, their varnished timbers spanning two stone pedestals, or an ordinary raised flowerbed, or a straight barrier to stop children from rushing out onto the street. Instead she called up this flock of forms, both useful and beautiful – 'captured by a building', in a way, although still more or less at large, not penned in by unfeeling squares and oblongs.

They are akin to some of Andy's works: the swathe of windblown spruce that veers like an anaconda through the shade in Grizedale Forest; the 'wall

SHAP, CUMBRIA
13 JUNE 1997

that went for a walk' between the trees in that same woodland; the 'Lambton Worm' earthwork made of old coking cinder on the dismantled railway line between Consett and Sunderland. All this for me belongs to the most fertile artistic movement of our time – the work with local materials that has been done in the Forest of Dean, in the Eden Benchmarks project, on the Gateshead bank of the Tyne, in the places mentioned above and in many others all over the country. Such works balance beautifully on the cusp between nature and artefact, between the practical and the fanciful, between craft and art,

Friday 13th June

I like the idea of dialogue between the drove arch and arches in buildings. The arch is like a bridge between building and quarry, between the smooth, cut stone and its origin. It has the instinct of an animal towards its own kind.

On my way home last night I'd been looking out for the school in Shap which I had visited once before. As I was driving down the main street I saw a building with three arches facing the road – a great place to make the arch, which turned out to be directly opposite the school. I had told the children I would make the arch here; now I can make it where they can see it and in a place where I really want it to be.

The window has been blocked in, so is now embedded in the wall, like an archaeological memory or a fossil. Perhaps the arch could be incorporated into its final resting-place in the hut in a similar way.

Thunderstone

The site I have been most looking forward to: the meeting of the
arch with the glacial boulder. Two travelling stones. I was very lucky
to find a fold next to such a stone.

between the figurative and the abstract, the accessible and the far-fetched.
They extend us without confusing or punishing us. They are scrupulously made,
neither strained nor precious.

Some of them tease. Presently teachers come out of the school with a croco-
dile of nine-year-olds and shepherd them across the main road for a closer look
at this funny pink thing that has come to a halt in the middle of their village.
As they crowd round and Andy chats with them, I can sense some of that slightly
baffled and tolerant curiosity with which schoolchildren greet the latest offer-
ing from the adult world – an art gallery, a Roman fort. Four or five years later
some of them will be sniggering, scoffing, baiting their teachers with spoof
questions, or turning away in a glaze of indifference. These young ones, in Shap,
are still willing to follow the Pied Piper. Several of them even turn up when at
last we make it to the thunderstone.

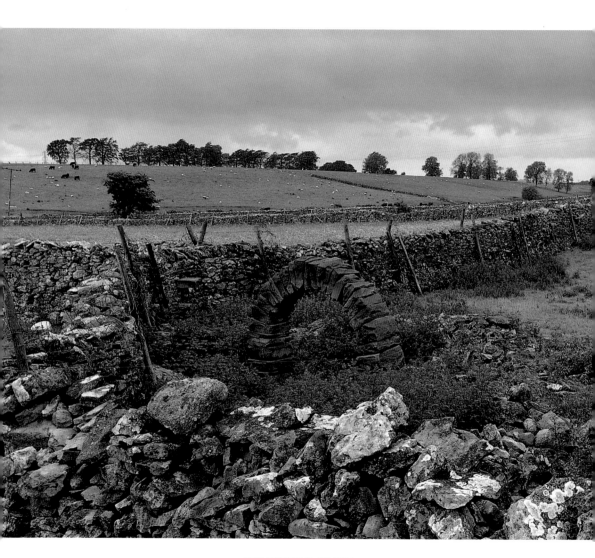

THUNDERSTONE, CUMBRIA
13 JUNE 1997

It perches on the ridge between Upper Lunesdale and the old drovers' (and drivers') way south to Kendal, the route followed by the road from Lancaster to Scotland little more than thirty years ago, before the motorway was driven through Tebay gorge. Once again, a granite erratic has been left on the limestone upland like a colossal whelk stranded by the ebb tide. The arch will nestle in a ruined fold where the drystone dykes bounding many fields meet at a little beck where sheep can drink.

A sheepfold is a 'fank', from the Irish Gaelic *fang*, and next to it in meaning is 'fankle', a tangle, a messy knot. The pastoral people must have seen the fold as a loop tied in a strand of stones. Although many folds are square or oblong (like the fourteen that Andy built or reconstructed twenty miles south-east of here at Casterton in Lunesdale), many others are circular or oval. I remember being told by a crofter at Gartymore in Sutherland that they were built curved (with the stones of the houses from which his great-grandparents had been evicted) so that in heavy snowfall the penned sheep would trot round and round, and stay alive, whereas if there were corners they would huddle into them and smother as the drifts deepened.

The walls up here ripple away on every side, yards and yards of them, adapting themselves to the lie of the humpy grassland. Some meet at a right angle, many waver unpredictably, following the wallers' sense of where the best footing was to be found. All across the north, where stone is plentiful, walling was, of course, fundamental. Patiently the men laid stone on stone – patiently, not slowly. I remember two veterans in Swaledale arguing vehemently as to who had been the best of the wallers before the Great War: 'Johnny Sunter never lifted a stone up twice,' said one. 'Neither did Willy Wagstaff!' riposted the other almost angrily. When I watched Douglas Hartley repairing a dyke at Low Ground in Dent, the stones from the heap seemed to spring into his hands as he laid them across and along for the new bottom course. The dykes that stride straight up the fellsides remind us of the surveying and re-lotting of land that followed the Tithe Acts early in the nineteenth century, and of the wallers who were kept going by the puddings that their wives wrapped in cloths and carried up to them.

Now the dykes are slowly unravelling, slumping and losing stones at rickety points, the gateways often lacking a gate. With the enlarging of farms and the

shrinking of the country population, one farmer may own, or rent, all the fields you can see, and his hordes of sheep, perhaps with a few beef cattle, can stray through any gap they like.

The arch is looking healthy, fresh rose and peach, ham and salmon, whereas the weathered and lichenous stones of this place, the necessary stones, have almost had their day and are eked out here and there with a strand or two of barbed wire strung on stakes. These twenty-nine stones of ours (I am feeling one of the family now) have darkened as the rains of the last two days have soaked in. In each stone, the wetter parts shade exquisitely to the drier, from terra cotta to palest guava. It's as though someone has come back from holiday with an enviable tan, or a foreigner has arrived whose pigmented skin reminds us of sunnier climates. The other stranger is the thunderstone. This great boulder, as big as a car, sits on the nearest skyline, at the verge of the little quarry where the wallers howked out their stone. (In Orkney it would be called a *hamar*.) Characteristically for granite, the rock shows layering where the plutonic material, freed from its compression in the Earth's crust, sprang outwards as the surrounding stuff wore away and left blind cracks parallel with the ground. They make frog or turtle mouths in the tors on Dartmoor and on Ben Avon in the Cairngorms. The north-west face of this Cumberland boulder has the look of a tortoise with its eyes shut or a rather glum dolphin. When the children arrive with a teacher, they listen dutifully to Andy's words about the arch, then hive off to the thunderstone and swarm all over it like a tribe of happy monkeys. When they leave, and we look at its rounded mass through the arch, the sandstone semi-circle has become the upper iris and the boulder is the pupil.

You might have thought that the motorway, such a depth of tarmac and crushed stone, cleaving so directly from place to place, would offer no berth for a drifting arch. Long before the cattle droves, still longer before the HGVs and holiday coaches, the boulders were moving east-south-east on the growing ice, plucked from that hill of granite which is coming into sight now in the north-west under the skirts of the clearing rainclouds. Three of the stones, a big one, a little one, and one of middle size, fetched up on the rib of ground that divides the north- and south-bound carriageways of the M6 where they are a hundred yards apart. It is a prehistoric stance and also a technical challenge.

BY THE M6 BETWEEN SHAP AND TEBAY, CUMBRIA
13 JUNE 1997

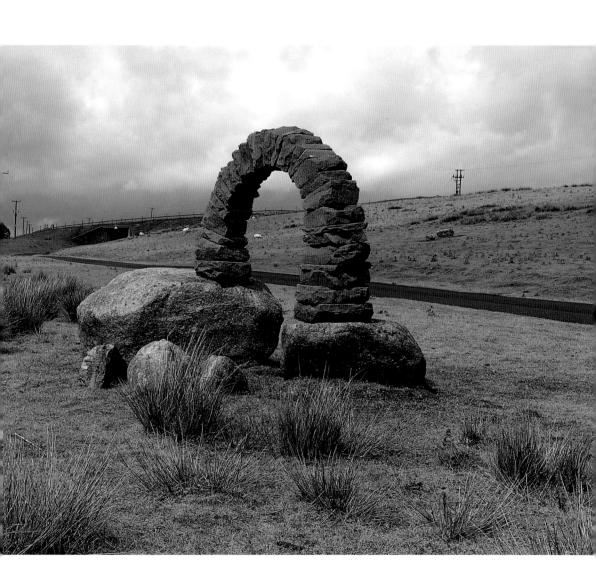

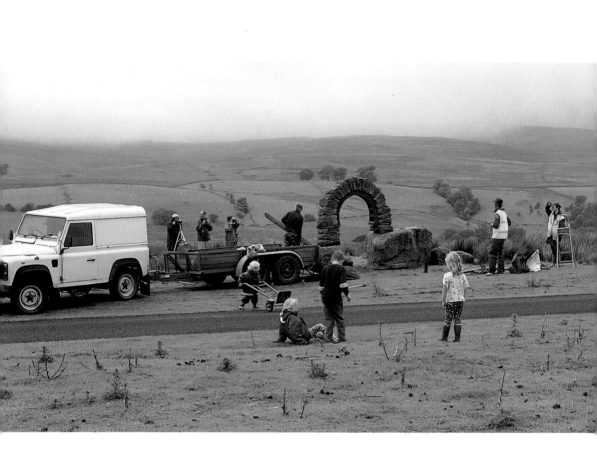

Can the sandstone feet lodge steadily enough on these glacier-rounded surfaces? The arch will only just span the gap between the big one and the middling one. So how will the wooden form, with its smaller diameter, stay put with nothing to stand on? Position several sandstones on each of the 'piers', with more wee stone wedges than usual hammered in under them to stop them sliding off. Trap pieces of plywood between the lower stones at each end of the arch, jutting inwards, and stand the wooden feet on these thin, airy supports. It still needs

By the M6 between Shap and Tebay, Cumbria

An incredible location, especially with the motorway behind. It rained, then the sun came out, the arch going deep red with wet. It was a difficult arch to make, but it spanned the two stones exactly – as if they were waiting for it. One side of the arch was much higher than the other. Dismantling the arch was precarious, but we succeeded.

I would have liked to have made the arch once more on a rounded tunnel underneath the railway line, but just did not have enough energy for that and the one at Scout Green. It was important for the arch to rest overnight in a fold.

propping with a couple of timbers, one at each side. Most of us are probably expecting some crisis, even collapse. It isn't quite sawing the lady in half but imaginary chords from the band can almost be heard as Andy moves in to lift the form away from under the completed arch. Out it comes... Not a tremor from the stonework... Nobody is actually offering to stand on top of it... As everyone claps, Andy slips into his showman self, puts the form across his shoulders like a yoke, and mimes Atlas straining under the weight of his globe.

continued on page 69

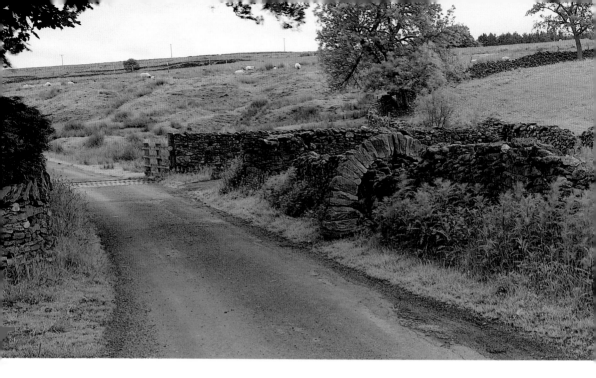

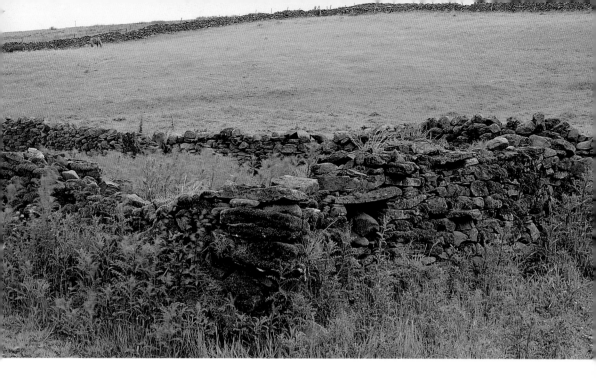

SCOUT GREEN, CUMBRIA
14 JUNE 1997

A long, semi-derelict fold with a few gaps and sags, though none
down to the ground. Made the arch stepping over one of the dips
in the wall. The people in the two or three houses nearby didn't
know what was going on, but were soon bringing out cups of tea.
It's surprising how many people have said, 'you should leave it
there', even on the pavement in Shap.

The story of the arch is getting richer. It is important that its journey
is witnessed by people. At the moment they can't see the whole
journey, but that will come later in the form of images and words.
The memory of the arch will give life to the story told not just by
records of my work, but by the people who have seen it.

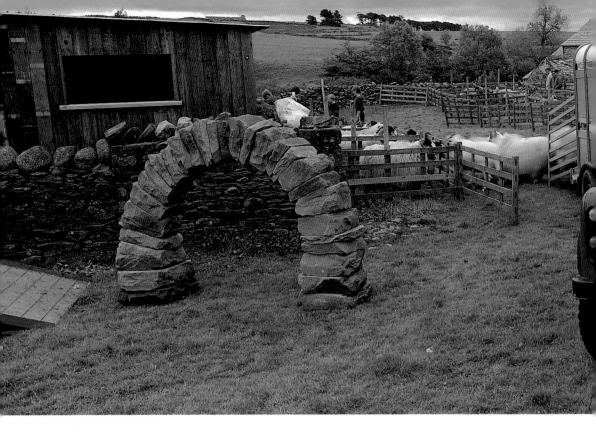

GREENHOLME SHOW, CUMBRIA
14 JUNE 1997

Saturday 14th June

Dull morning, didn't stay too long at Scout Green. The farmer who looks after the fold there turns out to be on the committee of the local show, and he asked if I would take the arch there. We made it to one side of the showfield behind the wooden pens into which the farmers were unloading their sheep. It felt good. I am sure some of the farmers were a bit bemused, but I hope they will understand the idea later. Someone asked whether photographs of the arch's journey could be on view at next year's show.

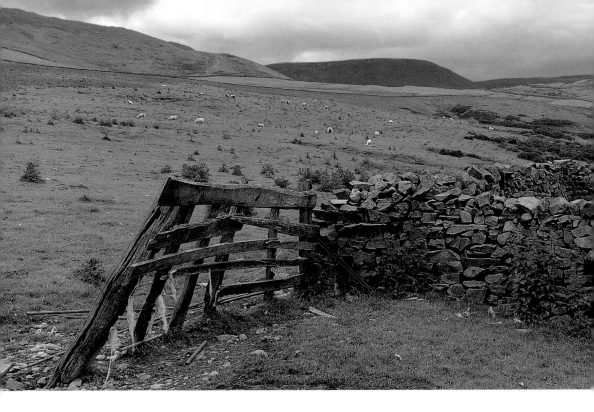

GRAYRIGG COMMON, CUMBRIA
14 JUNE 1997

This fold is sited next to the road, a simple square with an interesting bit of wooden fence. The hills beyond were dark. The arch was beginning to dry out, getting paler, the colour quite beautiful against the dull, dark sky.

Sunday 15th June

Rained overnight. Difficult access to the arch. Carried stones from the fold on to the trailer which was parked on the road. Met one of the commoners who came to look at his sheep. Learned some interesting things about the common.

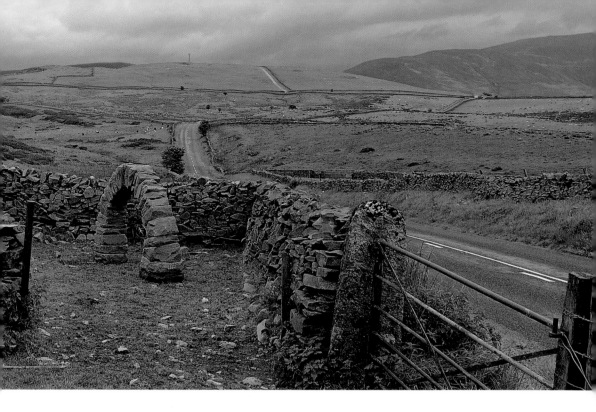

Continued the journey. The road drops down below the motorway. We have woven in and out and around and in some cases between the M6. Here there is an extraordinary viaduct with several of its arches built on a curve of red sandstone. Made the arch nearby, in view of the viaduct. As we worked, we were aware that people were watching us from the gardens and houses of the small hamlet of Lowgill. A farmer came out, drove his tractor down to see us and asked what was happening. He seemed quite gruff. I explained who I was and what I was doing. He had heard of me and there began a long conversation about art and farming. Accompanied by another resident, we went off to have a look at other arches around the village.

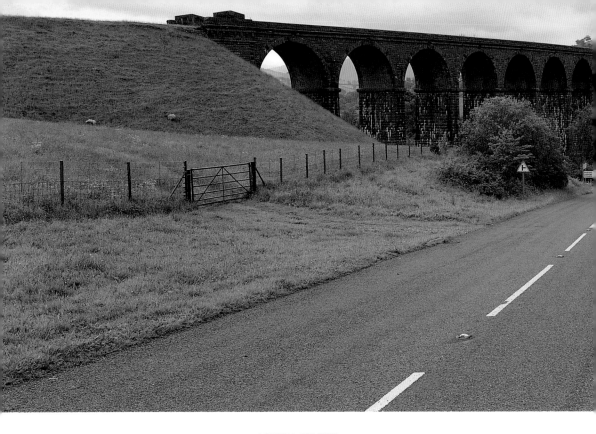

LOWGILL, CUMBRIA
15 JUNE 1997

We walked towards the viaduct looking up at its arches from a bridge beneath it. Below us was a beautiful old packhorse bridge. As the farmer commented, there must be twenty arches around here. What an appropriate place to make another. Building the arch has provoked some interesting conversations. People enjoy talking arches. Our conversation lasted the best part of an hour – an experience repeated in practically all the places we have visited.

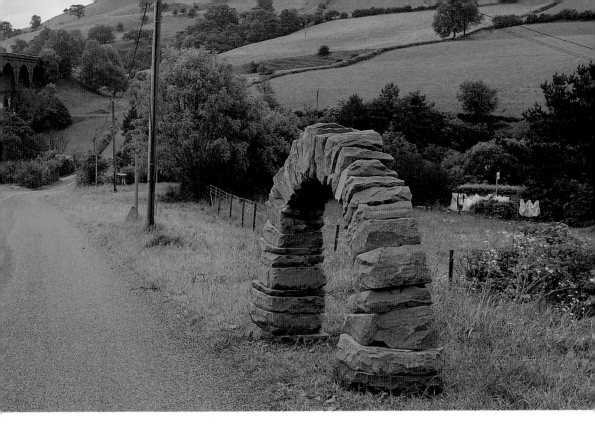

Inevitably when I arrive in a place with the arch, it is with a certain amount of trepidation. I don't really know how the situation will develop. There is bound to be some suspicion when someone turns up with a trailer. In one place the police soon came, but once I told them what I was doing there was no problem. In all the places we have been to, far from there being difficulties, there have been intense curiosity and interest about the arch. Tom Felix, from Shap Beck Quarry, continues to visit each site, bringing his family with him. Good to have someone who works with rock and knows it following the arch in this way.

Lambrigg, above the M6, Cumbria

After leaving Lowgill, we went along a road parallel to the M6 to two folds overlooking the motorway. The fold I intended to work in was on the right, although we were met by a farmer whose fold was on the left. He seemed keen for us to use it, but we'd already organised the one on the right.

This fold does not need much repair, although it is sagging all along the back wall. We will rebuild this wall. I placed the arch up against the gate. The sound of the motorway was very loud. Another good day.

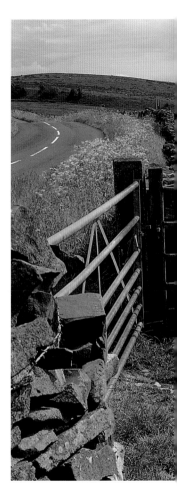

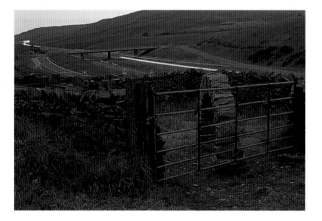

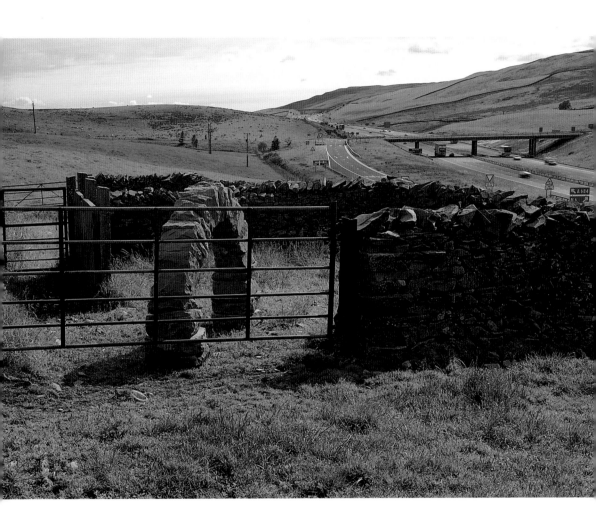

LAMBRIGG, ABOVE THE M6, CUMBRIA
15 JUNE 1997

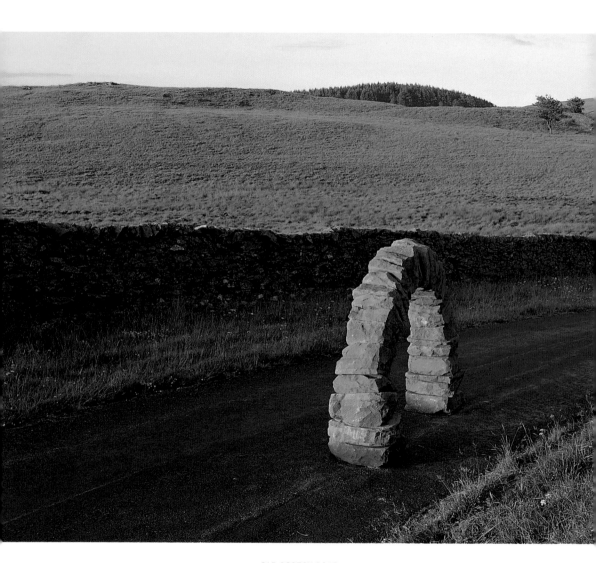

OLD SCOTCH ROAD
16 JUNE 1997

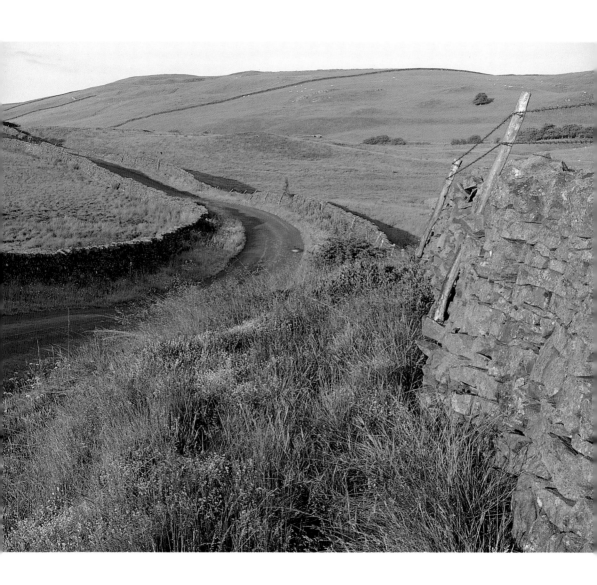

Monday 16th June, Old Scotch Road

Yesterday evening on my way to Casterton I took the route that we will be taking today. I had it in mind to make the arch on this road, which I remembered as being reasonably quiet. In fact, it is quite busy and narrow. The place where I wanted to make the arch was on a bend, making it even more difficult. I decided to get up early and arrived at the Old Scotch Road site at 4 am. Woke up Nigel and Katy who were camping in the field next to the fold where the arch was resting. It took about an hour to get everything packed up and the arch lifted away. I wanted this arch to be very firmly on the road, almost at its centre, not to the side like the arch near the viaduct. The place I chose was again bordered by wide grass verges and walls showing it to be a drove route, with bends and curves which I liked. The sun was rising as we finished building the arch, catching its top and gradually working its way down, completely illuminating it. It was extraordinary to see the arch so animated when placed on a road. The line of the road gives it a strong sense of direction. This image − of the arch astride, a walking stone arch − is extremely important. Finished around 6 to 7 am. Let it stand for a while, reluctant to take it down, it looked so well and right on the road.

Yesterday evening, the farmer who owns the land where the arch was resting in a fold came by. He knew nothing of what was going on. A mistake had been made in identifying who owned the fold as there are two folds very close together. Considering that the farmer found two people camping in his field cooking their evening meal, and a stone arch in his fold, he took it quite well and there was no problem, although I would have preferred this to have been avoided.

continued from page 55

After spending the weekend away in Argyll with the Cobbler and his wife Jean – the jagged snouts of diorite that crown Ben Arthur in Arrochar – I'm due to meet the arch again at Wyndhammere, near Old Town on the western slope of Lunesdale. For more than an hour I catch no glimpse of its curved red limb as I stravaig along narrow roads whose verges are brimming with red campion and cow-parsley and the luminous lettuce-greens of new hedge-leafage. One field in five is peopled by freshly shorn sheep. Lambs bleat raucously. The curlews high above them are tuning as liquidly as Acker Bilk's clarinet. One road running due south from Killington to Old Town has the abnormal width of a drove-way – Old Town used to have a cattle fair in October. The drovers typically followed uplands between one dale and another to avoid the frequent hedges of the riverlands. The arch would be at home here. I drive, then walk, down a track to Wyndhammere and find a long tarn in a fold of the fells, alive with mallards, coots, and mute swans. Might the travelling herds and flocks have watered here? No sign of an old pound or washfold that could have proffered a stance for the arch. On my third passage down the road – there it is, looking at me over a gritstone field wall. The sun is bending into the west, and the arch is dappled with shadows cast by an old oak. No people, no vehicles, no tools. Only the arch grazing peacefully in what seems to have been a scratch fold made from posts and corrugated iron in the right-angle of two walls.

I sit on a saddle-shaped boulder a few yards away and look through the arch, seeing the less glamorously coloured gritstones of the wall behind. I climb the oak and look down on it as a bird would. It seems extraordinarily still – always was here, always will be. Marinaded in warm air, my mind stills to a light trance, helped by this talisman beside me.

Summer has become permanent. Blue clouds brood thunder-eggs which thin and vanish when a light wind breathes from the north-west. The arch has entered into its element, sunlight, which shone on it when it was dunes and does so again now it has been exhumed by the Dumfriesshire quarrymen. It is trundling finally down the daleside towards Kirkby Lonsdale as though it was a full circle, not part of one. It comes to rest where a seam in the pasture opens and a beck wells into the daylight, sparkling. The old fold at the roadside, near the entry to Fellside, looks as though its walls were built up once and mortared to make a

An ancient sheepfold site, according to the map, but all that remains are a few posts, a bit of corrugated sheeting and the hump that shows where a fold may once have existed.

The farmer, Frank Mason and his sons came to watch the arch being put up. They were extremely enthusiastic and I enjoyed their company. We are making the fold a bit larger than it originally was, which I am very happy to do, because Mr Mason wants to be able to herd a good number of sheep. I like this fold because of the relationship of the arch and the tree.

Finished around midday. Went fishing on a nearby lake. Caught a good brown trout which we had superbly cooked at the Pheasant Inn, Castleton. We had a great time. Tomorrow will be the last day.

After some searching, we have found a resting place for the arch before it goes on to its final destination. It will stay in one of a series of quite interesting pig sties at Whelprigg.

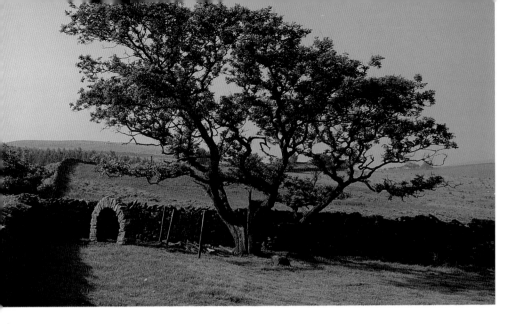

WYNDHAMMERE, CUMBRIA
16 JUNE 1997

little barn. A fit enclosure for the arch? Andy decides to build one foot on the road and the other in the herbage next to the ivy-mantled field dyke, as though to make a statement: cars have ousted us from the thoroughfares, almost, not entirely. During two hours of building and dismantling, six or seven cars come past and scarcely slow down. The exception is a vicar, who almost halts, smiles in an Anglican way, and seems about to wind down the window and bless us, thinks better of it and drives on. Road or not, in this cradle of grass and sheep and mature broad-leaved trees the arch is perfectly at home, standing on the verge like a gypsy horse whose owner doesn't mind at all if it stops hauling and steps aside to munch greenstuff from the hedge.

Half a mile up the hill lies the most beautiful caravanserai of the journey. A loop on the A65 just south of Tearnside is a remnant of the road's old course, from the days when even turnpikes clambered round outcrops, up steep braes, and down again into deep-cut gullies. Beside the old road we enter a dell of trees and flowers and rock as though through a valve, on the inner side of which

FELLSIDE, KIRKBY LONSDALE, CUMBRIA
17 JUNE 1997

Tuesday 17th June

Went on down the drove route. At the end it was difficult to decide which would be the last fold in Cumbria. There were two very interesting ones close together – too close, it wouldn't have made sense for the arch to stay overnight in two folds so near to each other, but I still wanted to include both in some way. So I decided to make the arch alongside one of the folds. I like the space

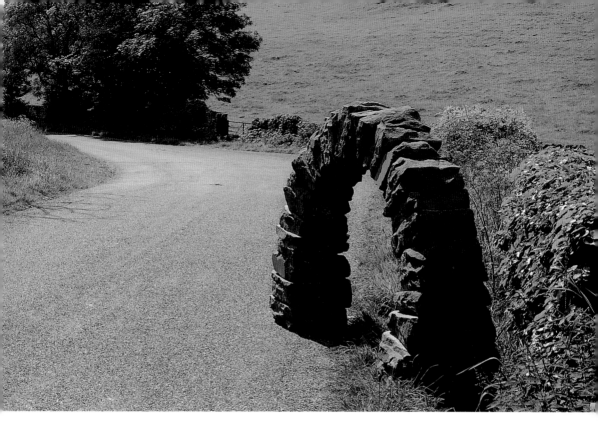

between arch and fold, the ambiguity as to whether it is going into the fold or out of it, or just passing by. The relationship between them makes the road take on the quality of a divider. I decided to make the arch both on and off the road. Worked very quickly because it was daytime and the road was quite busy. Although it made things a bit more hazardous, I liked the bend in the road, in itself an arch.

Tearnside

The final fold, in deep shadow. I will wait until tomorrow to take photographs. With luck the sun will be shining into the fold so that the stone face of the quarry as well as the arch and the interior of the fold will be visible.

Wednesday 18th June

A hazy sun illuminated the arch and fold beautifully. The colour was quite extraordinary. I am delighted by the colour changes the arch has gone through on its journey, brought on by how wet the stones have been made by the rain. We have had all weathers during the journey. In Scotland, it was partly dry the first day, dry and wet the next, and the arch has been in and out of the rain ever since. The stone turns a deep pinky red when wet and a pale pink when dry. Today it was dry. It took a long time for the base stones to dry out completely after standing in the stream at the quarry. The feet of the arch have changed as it has made its journey. At first it was a little heavy-footed, a bit stuck to the ground, so I trimmed the feet slightly. I also worked a bit on one of the stones that had very obvious sawn edges to it. I wanted the stones to remain cut as an indication of where they came from and the work that is done at the quarry. But in this particular stone, the cut edges were too loud, so I softened them off. I like the idea of the arch changing slightly throughout the journey, yet always remaining the same.

It has been good to get back in direct contact with farmers and people who live in Cumbria for this part of the Sheepfolds project. I have found it hard to work so publicly, especially when it is difficult to explain exactly what I am doing. It has also been necessary, though not easy, to deal with the anger and bitterness that is sometimes shown towards contemporary art. As it has turned out, the arch has been a great ambassador for the project.

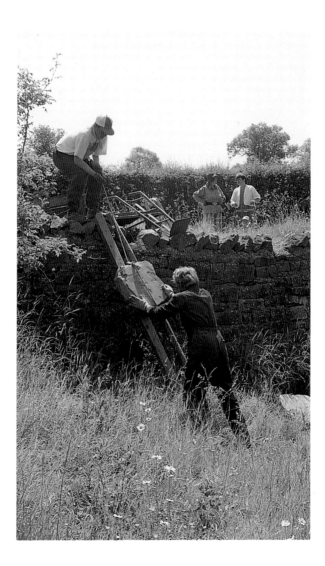

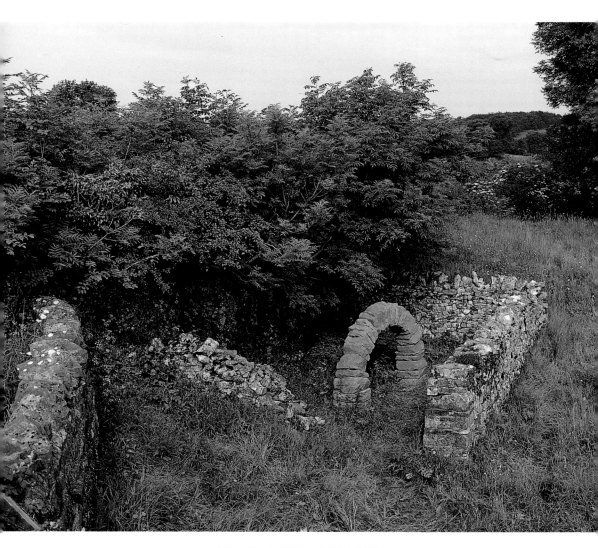

TEARNSIDE, KIRKBY LONSDALE, CUMBRIA
17-18 JUNE 1997

harsh noises and ugly things can no longer impinge –

> ... the island-valley of Avilion;
> Where falls not hail, or rain, or any snow,
> Nor ever wind blows loudly ...
>
> <div align="right">Morte d'Arthur Alfred, Lord Tennyson</div>

'There are worse places to work,' says Andy.

'Everywhere is a worse place to work,' I suggest.

He eyes the drop into the sheepfold ground and says, 'Well, it'll be a job getting the stones down there.'

Below the old road wall the ground falls steeply, vertically in places, cut away to get limestone for dykes, road-metal, and maybe to burn for fertiliser, generations ago. There is a drop of at least twelve feet, down which the stones must be lowered. Handing them is impossible. Andy, Nigel, and Katy rig up a homely system. The trailer is backed to the wall, two spars are leaned from the tailboard to the foot of the hollow, the stones are slid down them on a noose of rope, then carried the few yards to the half-ruined fold where the outcrop peaks and has been quarried in a vertical face. Ash-trees grow out of it now, their roots prising apart the brittle rock. From the floor of the hollow, elders spring to a surprising height, more trees than bushes, their blossoms massed into a sort of huge multiple cauliflower. Beneath the lattices of branches at least twenty-five species of wild flower (on my amateurish count) make a Sargasso of early summer colours, cream and butter-yellow and rose-pink.

The work goes peacefully. A small clan gathers: Steve Chettle, impresario of the project, from Cumbria Public Art, people from the antiques shop in a nearby hamlet, some of my family and other folk from Kirkby Lonsdale, my wife, her daughter-in-law and the two grandchildren, our dog, two more dogs... On the grassy bank at the south end they sit and watch like a little crowd at a sheep-dog trial. We are all lapped in sunlight and fresh smells, with a piece of benign work at the heart of it – akin to the atmosphere at a sheep-shearing, or when a horse is being shod at a smithy (a thing I saw just once, at Milton of Kildrummy in Aberdeenshire, during the first summer of the War). When the arch is complete, looking more compact than usual under the lour of the crag, and nearly everybody has gone away, Amy Spillard, aged five, dares to clamber up the arch

and tiptoe along its crest. She looks like a girl-ghost in an enchanted garden a hundred years ago.

All day we have lived in a place which is summer in a nutshell – in a pumpkin-rind, perhaps, or the calyx of a flower. The sun sinks into the wooded hills in the west, rises to shine full into the dell a few hours before the arch must be dismantled. For his next trick Andy mans the hand-winch mounted on the front of the trailer and hauls each stone up the spars by means of a steel hawser with a hook on which they have slung the rope noose. It's the only stage in the drove at which a modern mechanism has been used. Metal, oil, bolts and nuts. Previously they have been using only the oldest methods of 'building the Arc', in Katy's pun. Yesterday, standing on the empty trailer, Andy played with the rope, tossing it into the air and enjoying its arabesques against the blue, and I was reminded of his leaf, slate, and hazel-stick throws. You can't play games with a winch.

The end is nigh. The arch should have found its home down south in Lanca-shire or Yorkshire, but a site is still to be found. It will winter at Whelprigg, in a piggery disused since the War, at the back of Henry Bowring's handsome Tudor house near Casterton, close to the north end of Andy's newly built sheep-folds on Fellfoot Road. There each fold encloses a boulder massive as a bull. The arch is some other animal, striding athletically down the miles, or one of those irrepressible coil-springs that hump across the floor like a caterpillar and even go downstairs without help.

'It's been the right size of arch for the project.' Andy is thinking aloud.

'A sheep, not an elephant.'

'Between a sheep and a cow.'

'Why this size? How did you decide?'

'It was a comfortable sort of thing to make. What you gain in scale you lose in fluidity. We could do those extra, unexpected stops because it's rela-tively easy to build. They're a touch bigger than Goodwood [the herd of arches he made at Hat Hill in West Sussex]. More elegant, less club-footed. I've been chipping at these feet. Like paring hooves.'

On the sloping concrete floor of this little gritstone building, with only just room to turn round, the arch looms half as big again as it does in the open

air. The floor has no give, the feet can't snuggle into it, and stability is not all that easy to achieve. A slight twist comes into the bow and has to be corrected. The last stones are reluctant to settle in. Andy and Nigel engage in an extra-ordinary slow-motion dance, or Cumberland wrestling match, one on each side, shuffling and chesty, hefting stones out again a little, willing the others to flinch downward. They would surely need three hands each, if not four, to ease this strong, curved limb into its most comfortable posture. As several times before, the flanks of the arch have to be budged with a piece of board held against them and smacked with a mason's hammer. Presently all is sound and unmoving, stalled for the autumn and the winter.

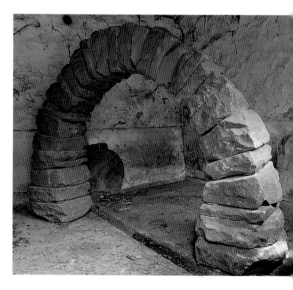

WHELPRIGG, CUMBRIA
18 JUNE 1997

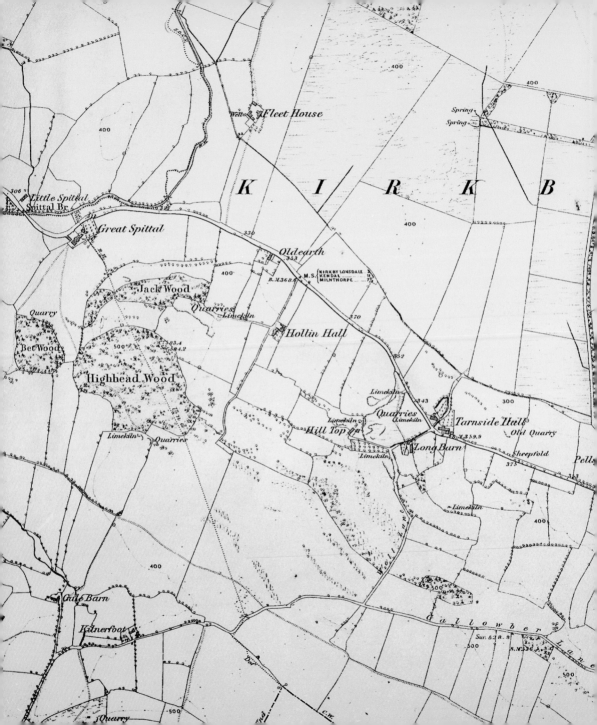